D0988011

BP PORTRAIT AWARD 2006

BP PORTRAIT AWARD 2006

National Portrait Gallery

Published in Great Britain by
National Portrait Gallery Publications,
National Portrait Gallery,
St Martin's Place, London WC2H 0HE

Published to accompany
the BP Portrait Award 2006,
held at the National Portrait Gallery, London,
from 15 June to 17 September 2006,
Aberdeen Art Gallery, Aberdeen,
from 25 November 2006 to 3 February 2007,
and at the Royal West of England Academy, Bristol,
from 31 March to 20 May 2007.

For a complete catalogue
of current publications
please write to the address above,
or visit our website at
www.npg.org.uk/publications

ISBN 1-85514-373-9
978-1-85514-373-9

A catalogue record for this book
is available from the British Library.

Publishing Manager: Celia Joicey
Editor: Caroline Brooke Johnson
Design: Anne Sørensen
Production Manager: Ruth Müller-Wirth
Photography: Prudence Cuming
Printed and bound in Italy

Cover: *Matthew* by Ben Jamie

bp

PREFACE

Scale is a dominant issue in portraiture: the small, intricate study draws the viewer in close, while the image of a face or body stretched across a large canvas pushes the spectator back to the point at which the image comes into focus. In both cases the viewer refers to their own body dimension. And that sense of our physical span gives a grounding to the making and viewing of portraits.

The human scale also connects with the contributing parts of the portrait: the clothing, the setting – whether complex interior or suggested landscape – and the narrative or symbolic elements. And a good portrait painter will employ any of these elements to convey the nature of the sitter that we, the viewers, wish to meet. Whatever the medium – principally oil or acrylic – or the technique (working directly from the subject or through the use of photographs) that search for the subject is at the heart of the Portrait Award.

Given the quality of the submissions, judging the 2006 Portrait Award was a delightful process, and this was another year with a record number of entries (1113). The judges view the portraits anonymously, simply examining each one and basing the decision in every case on what is conveyed of the sitter and the manner in which they are portrayed. Only after the artists for the exhibition are chosen and the shortlist of prize winners established, do we know anything of the location, gender or age of the artists.

Visitors will pick out which individual works they think are the best, but I hope they will also enjoy the skill and determination that these portraits represent as a group.

BP is a long-term partner for the Gallery, and their continuing support for the Portrait Award is an example of remarkable sponsorship that really makes a difference. I am delighted to have the support of the company and Lord Browne.

SANDY NAIRNE
Director, National Portrait Gallery

FOREWORD

BP recognizes the role that arts and culture play in the economic and social fabric of the country. We maintain a focus on excellence and on efforts to give as many people as possible access to that excellence. We support some of Britain's most outstanding cultural institutions, including the National Portrait Gallery.

Over the past sixteen years, the BP Portrait Award has consistently demonstrated the artistic potential of figurative art. The growth in the number of entrants and visitors to the exhibition, from across the United Kingdom and abroad, is encouraging evidence of the role of the Award in developing artistic talent and the understanding and appreciation of portraiture.

BP is delighted to be associated with the Award and to continue our partnership with the National Portrait Gallery, which has now been extended for a further five years. From 2007 onwards the Award will be open to everyone over the age of eighteen years of age. A new prize for artists aged between eighteen and thirty will also be created and awarded for the first time next year.

The skill and commitment of the Gallery's staff have turned what began as a small and experimental project into a sustained, internationally recognized success. Our thanks are due to them and, of course, to the artists whose ability to capture human character on a two-dimensional canvas is a rare and precious quality.

LORD BROWNE OF MADINGLEY
Group Chief Executive, BP

PORTRAITS AND BIOGRAPHY

All National Portrait Gallery portraits mentioned in this essay can be seen on the NPG website, www.npg.org.uk

During the whole of the last two years, I've sat down at my desk each morning and stared hard at a copy of a self-portrait by Gwen John (Tate Britain). I've had it propped up, centre stage as it were, so that if I lift my eyes even for a minute from what I'm writing Gwen John looks back at me. She has, in this portrait, painted in 1902, a determined expression and her pose is one of apparent confidence, but once I got to know something of her life and of the kind of woman she was, I began to read other things into how she presented herself. The book I was writing was not a biography but a novel, inspired by imagining what happened to one of her paintings, but I would have made no progress without an understanding of her life. Becoming familiar with her self-portrait was an essential part of this, but then portraits are essential to any biography.

They are the beginning. Other copies of portraits have sat on my desk and have exerted the same kind of hypnotic power. Every biographer needs a portrait of their subject before they can even begin to think of how to delineate a life and if none is available the loss is felt immediately. It is such a simple, almost crude, question: what did he or she *look* like? Should it matter? Perhaps not, but it does. The painted portrait tried to give the answer before the advent of photography (though each medium provides a different answer), but it was always constrained by the demands of the times in which it was being painted. The painter was not necessarily trying to achieve an exact likeness – the face, for centuries, was the least important part of the portrait. What mattered was giving an impression of status – it was the clothes, the jewels, the background that spoke loudest.

Nevertheless, there is still something to be learned from standing and staring even at Tudor portraits. Elizabeth I (NPG 5175) and Mary Queen of Scots (NPG 429) hang side by side in Room I of the National Portrait Gallery. Both artists are unknown but it is easy to understand their brief: these are women so they must be flattered. Their complexions must be blemish free. There are no lines on either face, no shadows under

the eyes, no sense of bone structure. We know from contemporary accounts that Mary was considered beautiful, but here she is no more beautiful than Elizabeth. All the emphasis is on the clothes and jewels, the eye contrasting the sumptuous dress of Elizabeth with the darkness of Mary's, and yet even this insistence on what they were wearing communicates so much. It is not just that Elizabeth is all power, that her dress shrieks wealth and status, but that it also conveys a sense of showmanship, an appreciation of how one looks being important. She understands, as does the unknown artist, that clothes speak to those who may not be able to hear any other language. And as for Mary's funereal black, relieved only by the fine lace of her collar and cuffs – exquisitely rendered – it dramatizes her perilous situation perfectly.

There are few portraits of women in the Tudor rooms, or in the next galleries, but then that is hardly surprising when the object of the painted portrait then was to laud the celebrity of the sitter rather than tell us about their life. Only queens and aristocratic ladies made the grade and what is learned from their portraits is much the same: what they wore, not what they were like. But then, slowly, women began to appear because of their achievements rather than their status, and it becomes exciting to glimpse from their portraits something of their character. There start to be layers of meaning to decipher and, though these are there to be caught in the portraits of men too, it is the women who benefit most.

Arriving at the self-portrait of Mary Beale (NPG 1687), painted c.1665, is tremendously significant because of why she is there at all: due to her work. She was a professional artist in an era when such a calling was virtually unknown, and she was extremely successful. Her portrait is a biography in itself. She shows us everything that is important to her. Her palette hangs behind her, her hand rests on her portrait of her sons: she is an artist, a mother and a wife, and also a woman who cared about her appearance – her hair carefully curled, her dress is of a rich material.

Her gaze is direct, her expression proud without being arrogant. A little later, in the eighteenth century, Angelica Kauffmann's self-portrait (NPG 430) has the same determination to show herself as both artist and woman, to tell us about what matters to her. She has her paintbrush in her right hand, while balancing her drawing book on her knee, and the forefinger of her left hand is pointing at herself: as if saying, this is me, the artist, above all else.

The painted portrait had not, of course, stopped concerning itself with status, and women had not ceased to be there because they were decorative. Portraits such as Thomas Gainsborough's *Mary, Countess Howe* (Kenwood House, London) seem entirely concerned with showing off the elegance of her costume and very little else. Her life, unlike Mary Beale's and Angelica Kauffmann's, hardly seems worth uncovering. Countess Howe exists to be admired. She is a creature of fashion. Her portrait amounts to a perfect composition but there is no drama there.

The Victorians changed all this – they seethed with curiosity, and their portraits reflect this. It is a shock as well as a thrill to arrive at Branwell Brontë's group portrait of his sisters (NPG 1725). In painterly terms this might be a roughly executed work but it banishes completely the idea of a portrait being about status or decoration: this is about character, about women who are struggling to fulfil dreams and finding it hard. The clothes are hardly noticed – a vague impression of dull black or green dresses, a hint of poor-looking muslin or cheap lace around the shoulders and that is all. There are no jewels, not a necklace or earring in sight. What draws the eye is the facial expressions, Charlotte's mouth set in almost a grim line, Emily and Anne with sullen pouts. There is an impatience about the grouping as though the artist was having to beg them to stay there just a moment longer – but no, they are not going to, they are not vain, they don't care enough to take the trouble to pose properly. The essence of these lives is caught, the spirit of the women, and gives rise to all kinds of theories about them, none of which can be

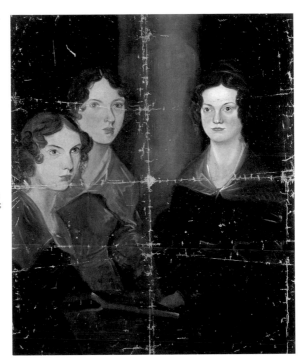

ANNE BRONTË, 1820–49;
EMILY BRONTË, 1818–48;
CHARLOTTE BRONTË,
1816–55
Patrick Branwell Brontë,
c.1834
Oil on canvas
902 x 746mm
(35½ x 29⅜")
National Portrait
Gallery (NPG 1725)

proved – every interpretation is valid – but that is what makes the portrait so moving. It is full of tantalizing hints about the relationship between these clever sisters and their brother.

Increasingly during the next century hints became not enough for the portrait painter. Hints began to expand into daring statements particularly where women were concerned. The Gwen John self-portrait, which has so obsessed me, has no paintbrushes or palettes in it – her pose and expression show an absolute determination to be serious about her work. She needs no props. She has her hand on her hip and stares straight out, confident, assured, inviting any onlooker to doubt her. There is something of the 'old master' style about her portrait, but she was not in any sense copying – she brings her own ideas to the pose. The only person she wanted to please with any portrait

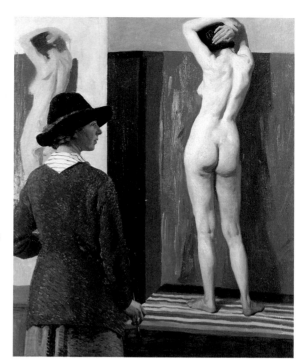

DAME LAURA KNIGHT,
1877–1970;
ELLA LOUISE NAPER,
1886–1972
Dame Laura Knight, 1913
Oil on canvas
1524 x 1276mm
(60 x 50¼")
National Portrait
Gallery (NPG 4839)

she painted was herself. Portraits, to her, were about the truth of what she saw.

As were Laura Knight's. Her self-portrait (NPG 4839), painted in 1913, makes an even more assured and important statement about what she thought she was doing. It is a daring, startling portrait, almost brash in its bold use of colour and its contrast between the clothed and the unclothed female form. The model's naked back commands attention but then immediately the expression on the face of the artist is more gripping – how cool she looks, how thoughtful and appraising. The relationship between artist and model, between woman and woman, is intriguing – it is impossible not to be inquisitive. Why the colour red? Just because the artist liked the colour or because she was fond of the cardigan she was wearing that day? And why the cardigan, worn as it is with that stylish hat? Then there is the striped mat

12

upon which the model stands – a bath mat? Does it matter? But that's the point – this is a portrait in which everything matters. The need to know exactly what was going on that day in the studio is so strong. It's enough to make a biographer desperate.

Increasingly, it is the psychological aspect of a portrait that proves the most compelling – it's the two-way communication between sitter and artist, and sometimes the sheer tension between them, that give the painted portrait its power. Take the portrait of Germaine Greer (NPG 6351) by Paula Rego. At first glance, it seems ugly – the sitter's posture, her legs awkwardly splayed, is ugly; the clumpy shoes, with what looks like a hole in them, are ugly; the frizzy, unbrushed, dun-coloured hair is ugly; and the scowl on the face is definitely ugly. But what is happening in this portrait is very far from ugly. This woman is listening intently and what she is hearing clearly disturbs her. Whatever caused the expression on Germaine Greer's face has silenced her, if momentarily. But there is the impression that she will not be silent for long – the hands will be unclenched, the feet firmly planted on the floor, and she will arise and speak out. Instead of being ugly, the portrait becomes inspiring. It is an example of the perfect match between sitter and artist.

For me, one of the most satisfying portraits from a biographical point of view is that of Dorothy Hodgkin (NPG 5797) by Maggi Hambling, painted in 1985 when the sitter was seventy-five. Dorothy Hodgkin is getting on with her work and nothing is going to interrupt her – she isn't even looking at the artist but is concentrating on studying what looks like a diagram. No concessions to vanity have been made – she hasn't bothered to brush her hair or think what to wear. The shelves behind her bulge with files and in the foreground is a model that might, or might not, have something to do with the structure of molecules. This is a woman who by then had been awarded the Nobel Prize for Chemistry and had been admitted to the Order of Merit (the first woman to be so honoured since Florence Nightingale) and yet there is not a shred of self-importance visible, not a medal

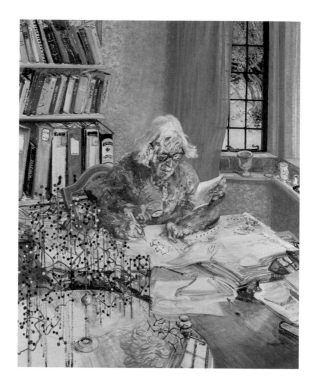

DOROTHY HODGKIN,
1910–94
Maggi Hambling, 1985
Oil on canvas
932 x 760mm
(36¾ x 30")
National Portrait
Gallery (NPG 5797)

on show. All her life is there, or rather what mattered most – the work, strewn about her. I wonder, looking at it, whether there was any conversation at all, or was the artist ignored? Was Dorothy Hodgkin so intent on what she was doing that she forgot the presence of Maggi Hambling?

There is a theory that the finished portrait reveals as much about the artist as about the sitter. Portrait painters gave up being intimidated long ago. Now, they can make their own feelings known and dare to be boldly suggestive. This is evident in some royal portraits. Since Pietro Annigoni's portrait *Queen Elizabeth II* (NPG 33/ 2004) in 1969, there's been a determination on the part of the artists concerned to be more adventurous. Their relationship with the royal personage can never be easy – it is hard to imagine anything remotely approaching a relaxed atmosphere existing in these sittings. Annigoni

seems to have wanted to show how heavy the burden of being monarch weighed on the Queen, how alone she seemed to him beneath all her responsibilities. The result is troubling, but then perhaps we should be troubled by the implications of this portrait – it arouses an unexpected sympathy, it makes us worry about this solemn-faced, still-young woman.

But today, that is what we have come to expect: that the portrait painter should take risks. We are not as interested in hero worship any more, though we still have our heroes and like to see them painted. When the National Portrait Gallery was founded, it was the celebrity of the person painted that counted not the merit of the artist, but now, with the BP Portrait Award, it is the artist who matters more. This seems to me to demonstrate that portraiture is going in a much more meaningful direction, intent on revealing to us much more profoundly not only the famous but the world in which the famous live. The BP Portrait Award opens that world to us most satisfactorily. The sitters may be almost entirely unknown but their anonymity does not mean they lack significance. A life can be created from studying the portrait of an unknown person just from paying attention to how the artist has painted them. And there is another element too – portraits are more and more paintings that reflect the various developments in art. How they are painted is as important as who is being painted. Once, the painted portrait was always figurative but for a century now it has been anything it wanted to be – cubist, abstract, surreal for example – and it is all the better for this freedom.

People communicate with portraits without necessarily knowing anything about the sitters except what the portrait tells them. And this is why portraits, especially painted portraits – because of that longer relationship between sitter and artist – are so vital to biography. Without them, the biographer would not have the key to opening the door on a life.

MARGARET FORSTER
Novelist and biographer

BP PORTRAIT AWARD 2006

The Portrait Award, now in its twenty-seventh year at the National Portrait Gallery and seventeenth year of sponsorship by BP, is an annual event.

It is aimed at encouraging young artists from around the world, aged between eighteen and forty, to focus upon and develop portraiture within their work. Many of the exhibiting artists have gained commissions as a result of the interest aroused by the Portrait Award.

THE JUDGES

Chair: Sandy Nairne, Director, National Portrait Gallery

Sarah Howgate, Contemporary Curator, National Portrait Gallery

Waldemar Januszczak, art critic and journalist

Lucy Jones, artist

Des Violaris, Director, UK Arts & Culture, BP

THE PRIZE WINNERS

First Prize
Andrew Tift who receives £25,000, plus at the judges's discretion a commission worth £4,000 to paint a well-known person

Second Prize
Rafael Rodriguez Cruz who receives £6,000

Third Prize
Angela Reilly who receives £4,000

PRIZE-WINNING PORTRAITS

KITTY
Andrew Tift
Acrylic on board, triptych, each 350 x 250mm (13³/₄ x 9⁷/₈")

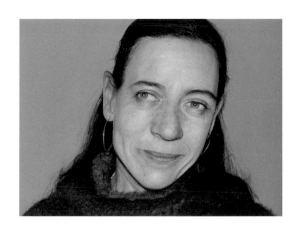

FROM THE SERIES MODEL FOR A
SELF-PORTRAIT 'MODEL 1 (LOLA)'
Rafael Rodriguez Cruz
Oil on canvas, 300 x 400mm (11^{7}/$_{8}$ x 15^{3}/$_{4}$")

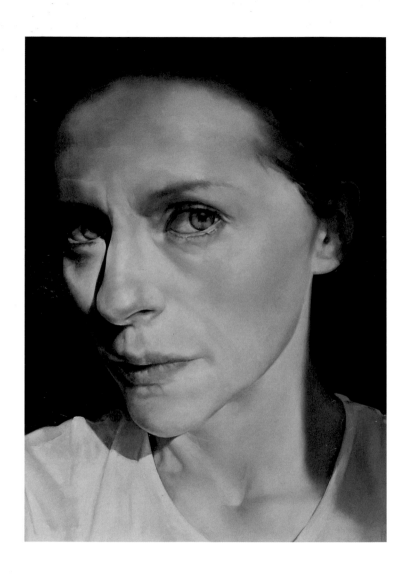

SELF-PORTRAIT
Angela Reilly
Oil on canvas, 1230 x 925mm (48³/₈ x 36³/₈")

20

SELECTED PORTRAITS

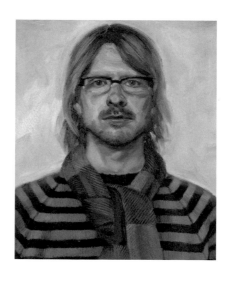

SELF-PORTRAIT
Joseph Avery
Oil on board, 300 x 250mm (11$^3/_4$ x 9$^7/_8$")

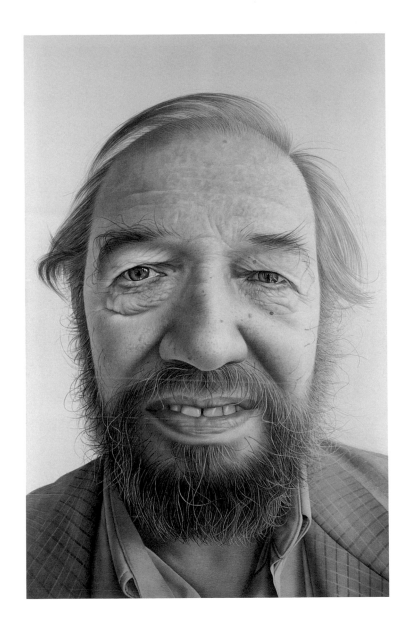

POET LAUREATE
Annemarie Busschers
Acrylic on canvas, 2500 x 1600mm (98³⁄₈ x 63")

23

NAPI
Gregory Cumins
Ink on canvas, 1500 x 1500mm (59 x 59")

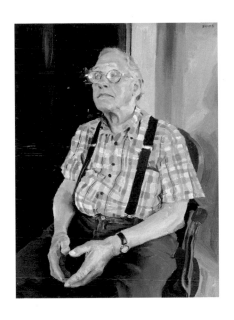

SEATED MAN
Michael De Brito
Oil on canvas, 555 x 400mm (21⁷/₈ x 15³/₄")

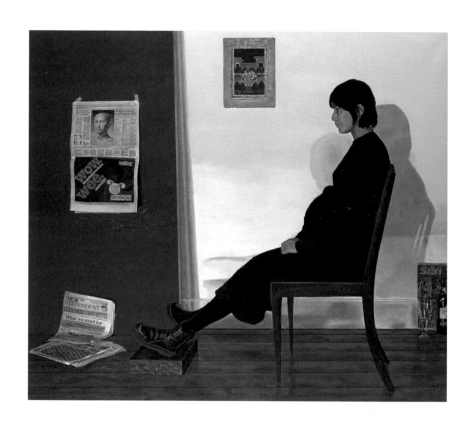

PORTRAIT OF THE ARTIST'S WIFE
J.J. Delvine
Acrylic on canvas, 1440 x 1635mm (56³/₄ x 64³/₈")

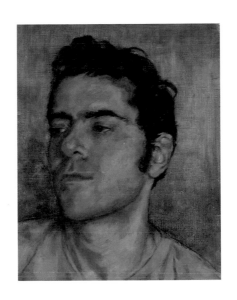

JAEMI
Clara Drummond
Oil on board, 325 x 255mm (12³/₄ x 10")

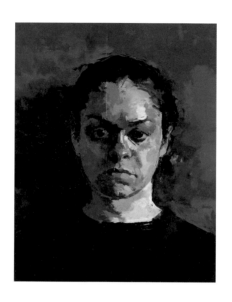

ROSIE SEKERS
Robert Dukes
Oil on board, 350 x 275mm (13³/₄ x 10⁷/₈")

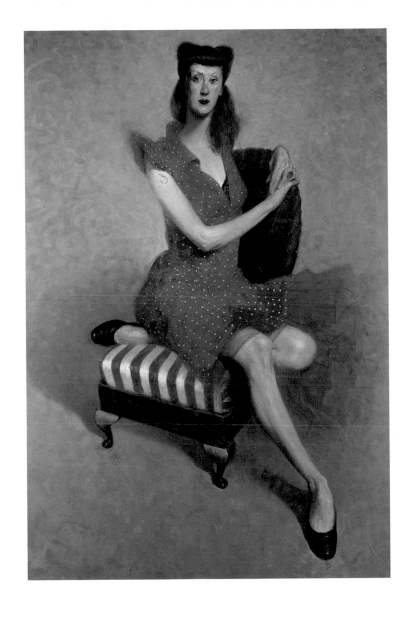

SARAH
Darvish Fakhr
Oil on canvas, 3050 x 2040mm (120 x 80$^3/_8$")

29

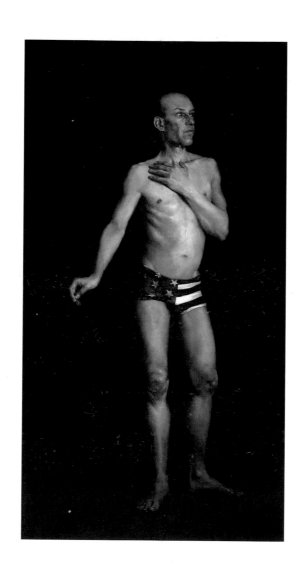

NO TITLE
Irene Ferguson
Oil on canvas, 1320 x 715mm (52 x 28$\frac{1}{8}$")

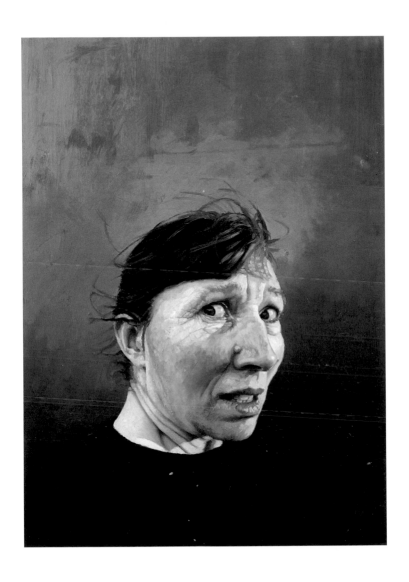

UNTITLED
David Fulford
Oil on canvas, 1200 x 850mm (47$^{1}/_{4}$ x 33$^{1}/_{2}$")

31

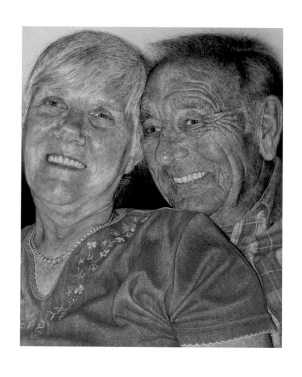

MR & MRS GARDINER
Iain Gardiner
Oil on canvas, 565 x 460mm (22^{1}/$_{4}$ x 18^{1}/$_{8}$")

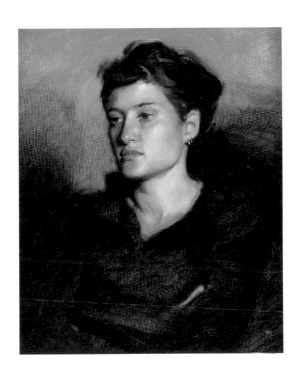

SILVIA
Vanessa Garwood
Oil on canvas, 590 x 490mm (23¹/₄ x 19¹/₄")

33

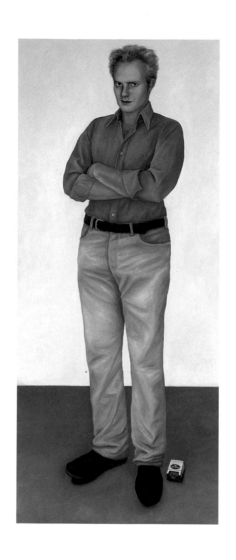

THE LATE JOSHUA COMPSTON
Nicola Green
Oil on board, 1830 x 760mm (72 x 29⁷/₈")

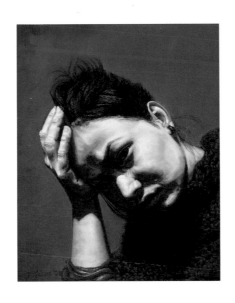

WORRIED
Barry Haines
Oil on linen, 285 x 235mm (11$^{1}/_{4}$ x 9$^{1}/_{4}$")

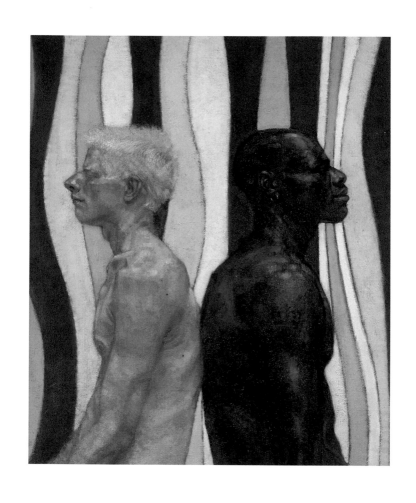

HERMES AND GEORGE
Howard Craig Hanna
Oil on canvas, 900 x 805mm (35³/₈ x 31³/₄")

36

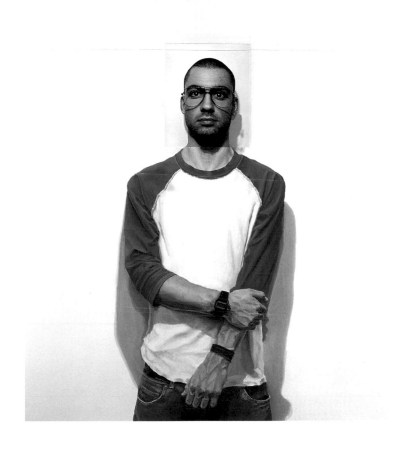

WATCH NOW
Andrew Hilling
Acrylic and mixed media on canvas, 1220 x 970mm (48 x 38$^1/_8$")

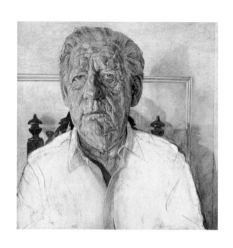

ROGER HOLLOWAY
Leo Holloway
Egg tempera on oak board, 230 x 230mm (9 x 9")

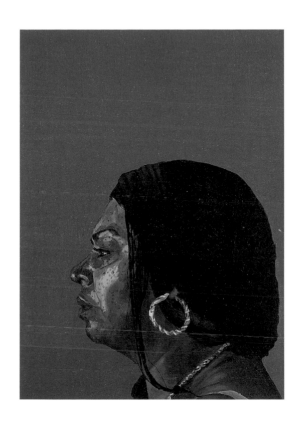

BEGINNING
Alexander Innes
Oil on canvas, 395 x 295mm (15^1/$_2$ x 11^5/$_8$")

39

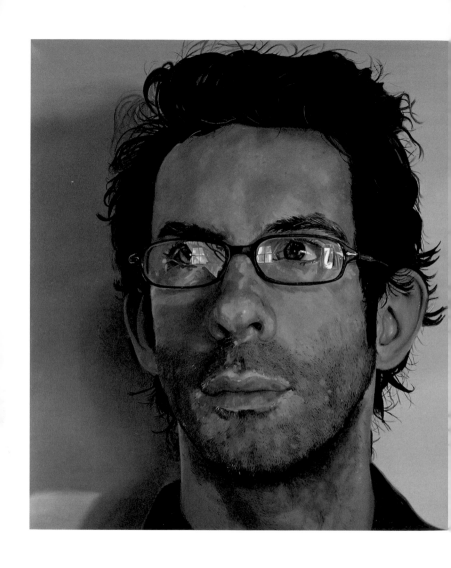

MATTHEW
Ben Jamie
Oil on linen, 1020 x 864mm (40^1/$_8$ x 34")

40

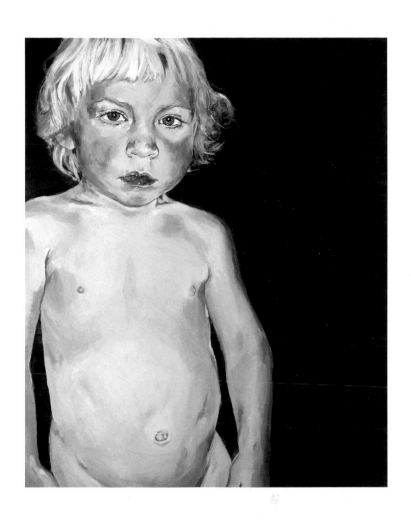

LEON
Aleksandra Jarosz Laszlo
Acrylic on canvas, 1000 x 810mm (39³/₈ x 31⁷/₈")

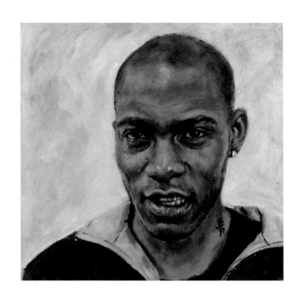

MARLON
Jon Jones
Oil on board, 380 x 380mm (15 x 15")

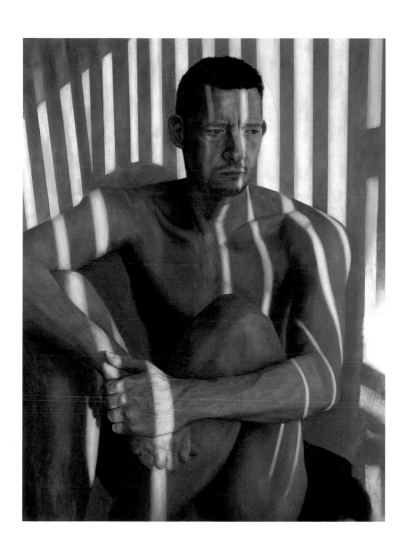

WILL
Shi-Chi Lin
Oil on canvas, 1220 x 915mm (48 x 36")

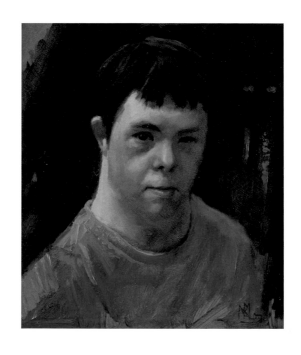

PORTRAIT OF MATTHEW
Norman Long
Oil on board, 410 x 355mm (16$^1/_8$ x 14")

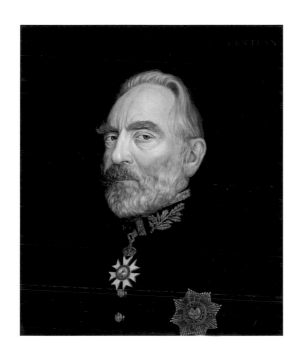

BRITISH AMBASSADOR
Gentian Lulanaj
Oil on board, 510 x 430mm (20 x 17")

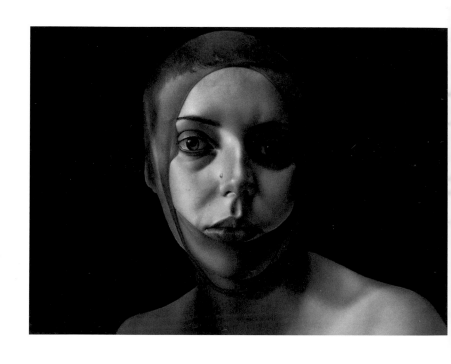

SELF-PORTRAIT
Ana-Maria Micu
Oil on canvas, 900 x 1200mm (35³/₈ x 47¹/₄")

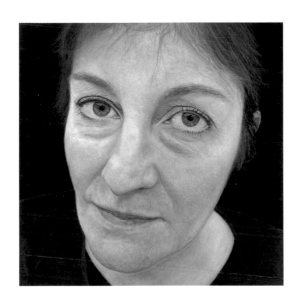

PERSONAL SPACE
Graham Milton
Oil on canvas, 920 x 920mm (36^1/$_4$ x 36^1/$_4$")

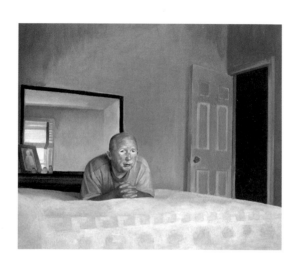

MY FATHER PRAYING
Grace O'Conner
Oil on canvas, 310 x 360mm (12$\frac{1}{4}$ x 14$\frac{1}{8}$")

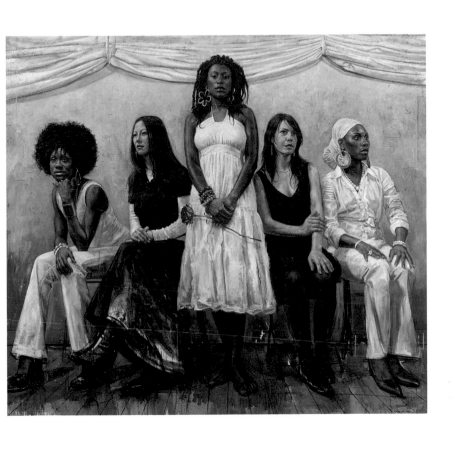

LA FAMILIA 3 (LES SOEURS)
Tim Okamura
Oil on canvas, 1930 x 2135mm (76 x 84")

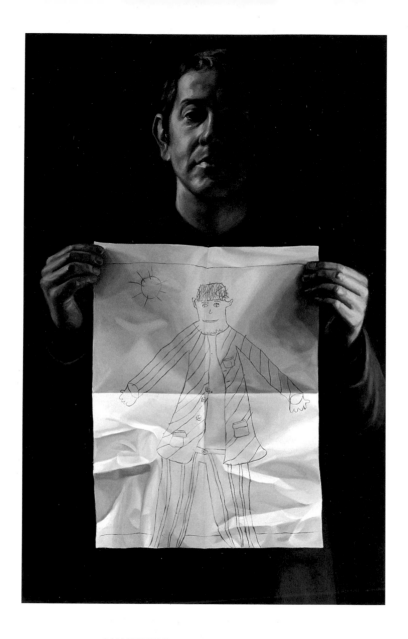

GALLERY MAN
Geraldine O'Neill
Oil on canvas, 1055 x 670mm (41$\frac{1}{2}$ x 26$\frac{3}{8}$")

50

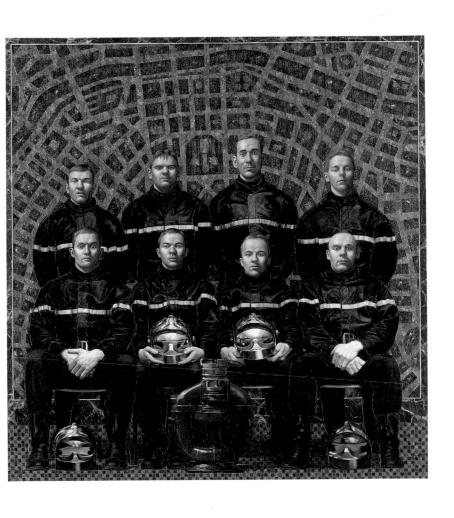

WHEN THOU WALKEST THROUGH THE FIRE
THOU SHALT NOT BE BURNED, NEITHER SHALL
THE FLAME KINDLE UPON THEE... ISAIAH 43:2
Sergio Ostroverhy
Oil on canvas, 2424 x 2298mm (95$^{3}/_{8}$ x 90$^{1}/_{2}$")

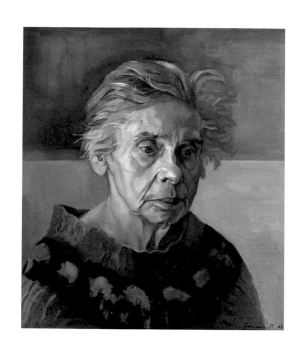

DEAR DEMENTED MOTHER
Jekaterina Pertoft
Oil on canvas, 635 x 555mm (25 x 21⁷/₈")

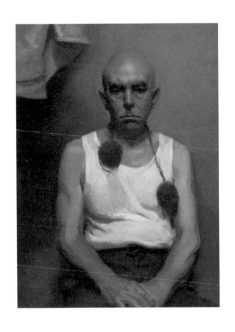

AGEING CLOWN
Anastasia Pollard
Oil on board, 390 x 290mm (15³/₈ x 11³/₈")

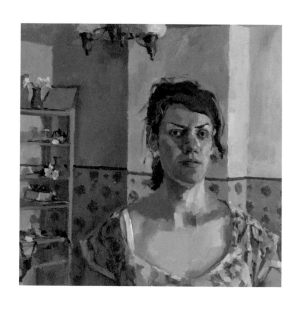

SELF-PORTRAIT WITH PINK ROSES
Erin Raedeke
Oil on canvas, 345 x 345mm (13⅝" x 13⅝")

54

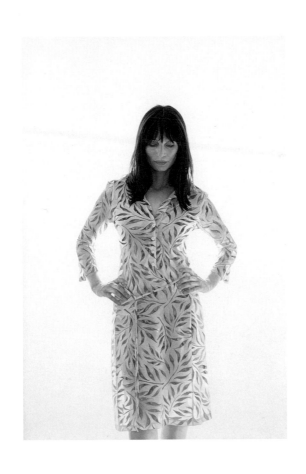

ILLUMINE
Stephen Earl Rogers
Oil on board, 420 x 290mm (16$^1/_2$ x 11$^3/_8$")

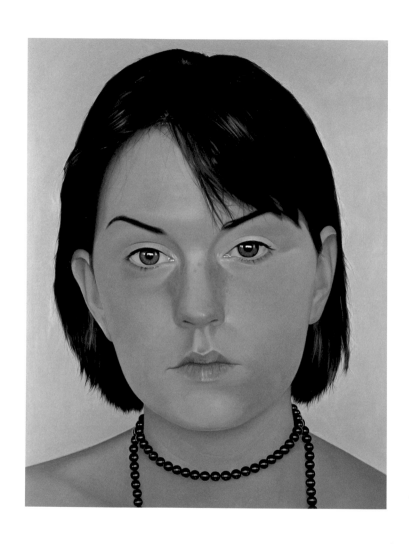

BLACK BEADS
Patricia Rorie
Oil on board, 1219 x 915mm (48 x 36")

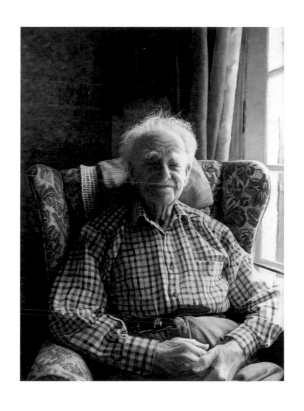

DR WAYPER
Rebecca Smith
Acrylic on board, 525 x 365mm (20⁵/₈ x 14³/₈")

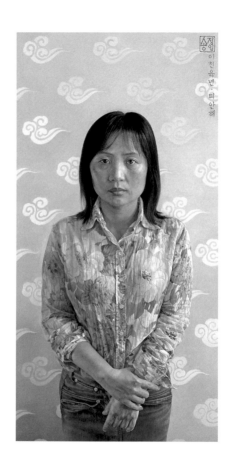

I AM SORRY!
Jung-Im Song
Oil on canvas, 800 x 400mm (31$\frac{1}{2}$ x 15$\frac{3}{4}$")

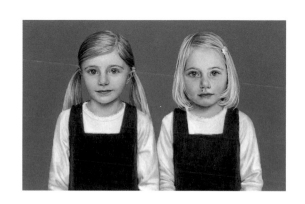

MY TWINS
Sarah Spencer
Oil on board, 235 x 350mm (9¹/₄ x 13³/₄")

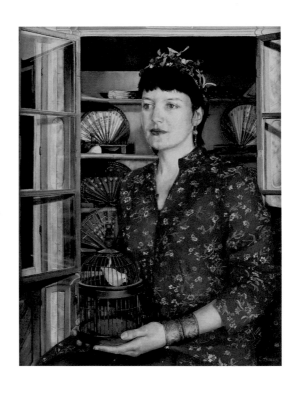

GERRY
Emily Stainer
Oil and acrylic on canvas, 700 x 550mm (27$\frac{1}{2}$ x 21$\frac{5}{8}$")

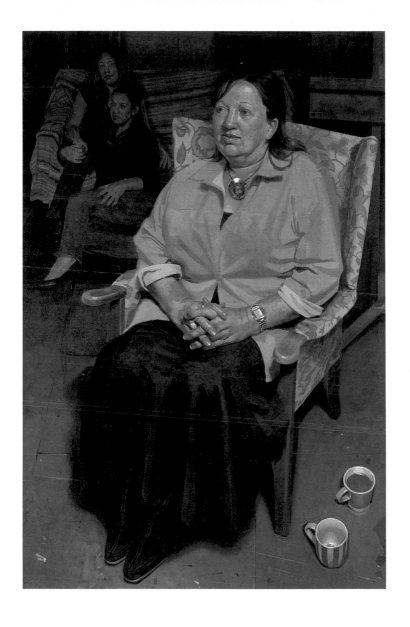

MANDY, GINNIE & KATIE
Benjamin Sullivan
Oil on canvas, 1110 x 760mm (43³/₄ x 29⁷/₈")

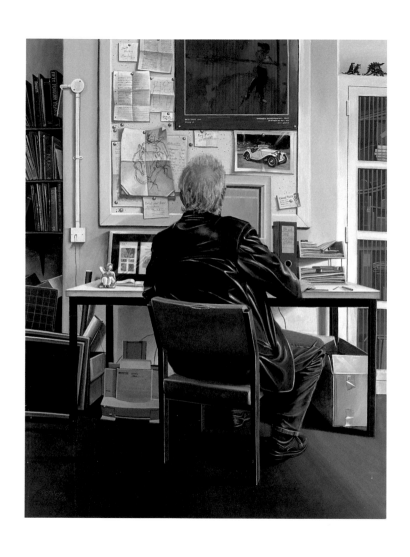

MY TUTOR
Craig Tiley
Acrylic on canvas, 1220 x 910mm (48 x 35$^7/_8$")

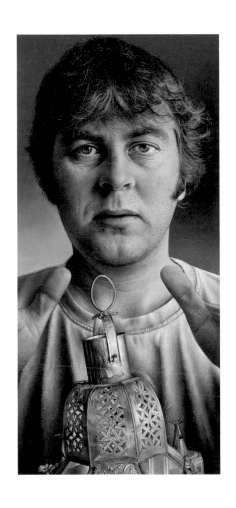

STRANGE CARGO
Stefan Towler
Oil on board, 550 x 270mm (21^5/$_8$ x 10^5/$_8$")

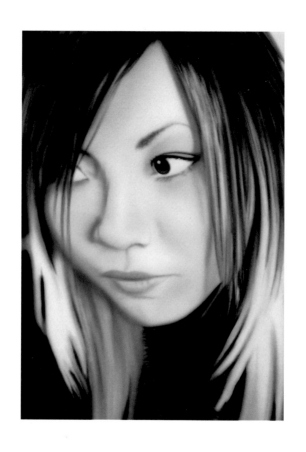

YUAN
William Tuck
Acrylic on canvas, 810 x 555mm (31$^7/_8$ x 21$^7/_8$")

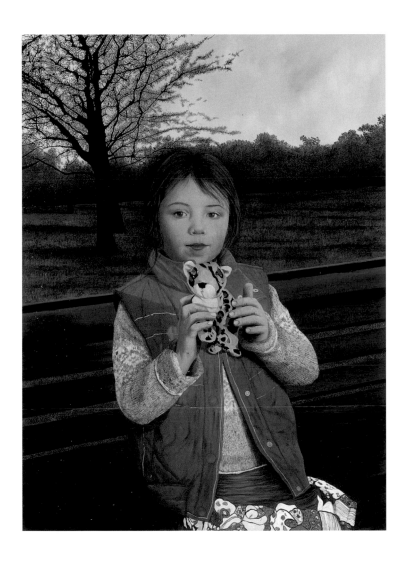

MOLLY JONES
Covadonga Valdes
Oil on linen, 940 x 690mm (37 x 27⅛")

65

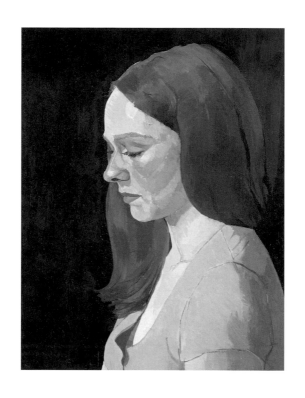

CONTEMPLATION
Adele Wagstaff
Oil on linen, 460 x 355mm (18¹/₈ x 14")

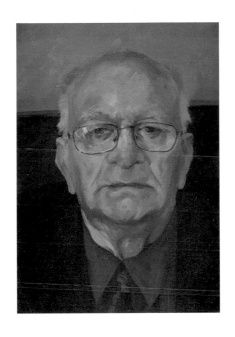

BRYAN PEARCE
Jason Walker
Oil on canvas, 345 x 245mm (13^1/$_2$ x 9^5/$_8$")

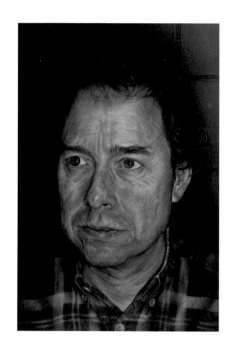

DONALD CLINE
Emma Wesley
Acrylic on board, 400 x 275mm ($15^{3}/_{4}$ x $10^{7}/_{8}$")

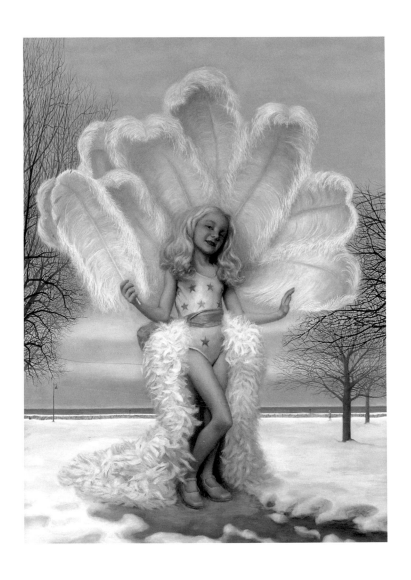

DAWN
Monica Whalley
Oil on board, 1530 x 1125mm (60¹/₄ x 44¹/₄")

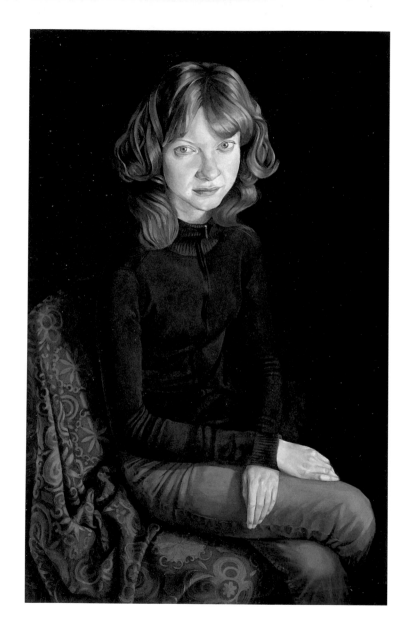

CATHERINE
Toby Wiggins
Oil on panel, 910 x 580mm (35$^{7}/_{8}$ x 22$^{7}/_{8}$")

SMILE
Katie Wright
Acrylic on board, 450 x 660mm (17³/₄ x 26")

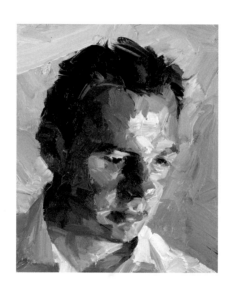

IAN
Paul Wright
Oil on canvas, 255 x 205mm (10 x 8")

72

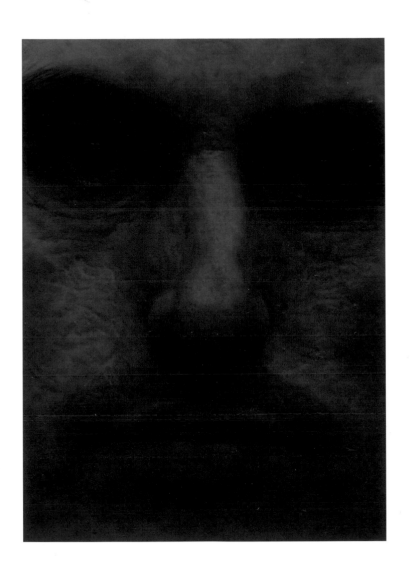

33
Craig Wylie
Oil on linen, 2340 x 1675mm (92$^{1}/_{8}$ x 66")

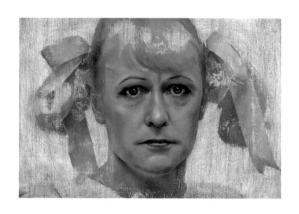

PORTRAIT
Jonathan Yeo
Oil on canvas, 260 x 360mm (10¹/₄ x 14¹/₈")

74

BP TRAVEL AWARD INFORMATION

Each year exhibitors are invited to submit a proposal for the BP Travel Award. The aim of the Award is to give an artist the opportunity to experience working in a different environment, in Britain or abroad, on a project related to portraiture. The artist's work is then shown as part of the following year's BP Portrait Award exhibition and tour.

THE JUDGES 2005 AND 2006

Sarah Howgate, Contemporary Curator,
National Portrait Gallery

Liz Rideal, Art Education Officer,
National Portrait Gallery

Des Violaris, Director, UK Arts & Culture, BP

THE PRIZE WINNER 2005

Joel Ely who received £4,000 for his proposal to paint the members of a Basque gastronomic society.

Joel Ely travelled to Bilbao in October 2005 to document members from a single *txoko*, a gastronomic society typical of the Basque region of Spain. Here he writes about his experience.

TXOKOS AND BASQUE TRADITION

Traditionally the exclusive domain of men, these *txokos* originated in 1870 in San Sebastián. They vary in size and each has its own set of rules and customs. The men gather in the kitchen to spend the evening cooking, talking, drinking and eating. *Txokos* function as both a practical and a social institution where all share the costs involved, but they can equally act as a means for the next generation to learn and preserve the long and much-lauded tradition of Basque cooking.

The Basques are anxious to maintain and promote their cultural identity and traditions. Through Juan Zabala, the president of *Txoko Mallona*, I met and interviewed *txoko* members, with whom I ate and cooked for. Here I collected source material for the portraits. I wanted to examine the role of food and authenticity in their culture as well as in mine.

Many of the men I met at the *txoko* and have subsequently painted grew up together under the Franco regime, when Euskera, the Basque language, was banned and food was scarce. They are a friendly and generous group of men, who after about thirty years of cooking in the *txoko* have become masterful cooks: delicate hake throats in a light batter, monkfish in a rich squid-ink sauce so thick and black it looked like tar and beef steaks served with *piquillo* pepper and garlic. In return I cooked a pork pie and piccalilli to feed twenty, green asparagus with butter, chicken curry and roast beef with Yorkshire pudding. But the dish that got them most excited was a simple steamed lemon and orange sponge pudding with custard (left).

After the BP Portrait Award exhibition finishes touring, the collection of portraits will return to Bilbao to be given to the members of *Txoko Mallona* in exchange for their time and help with this project.

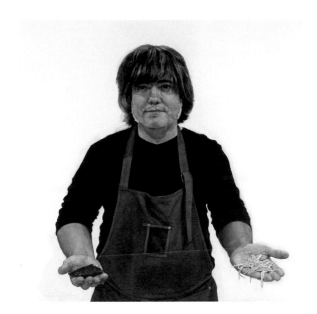

KIKO WITH PIQUILLO AND GULAS

While researching my project I contacted the London Basque Society and over time got to know Kiko Moraiz. Kiko grew up in San Sebastián and was invited to join a *txoko* but turned it down because he disagreed with the men-only policy. When he moved to London over a decade ago he missed the food and set about learning recipes. He now cooks a full four-course Basque meal once a month for fellow Basques in London.

Kiko is holding a stuffed *piquillo* (a type of red pepper grown in Navarra) in his right hand. This was the main dish of the first meal he cooked for me in London. In his left hand he holds a portion of *gulas*, a mechanically made substitute for *angulas* (baby eels) made out of surimi (also used to make artificial crabsticks). Baby eels were a highly prized dish in the Basque country for centuries and were traditionally fried quickly in olive oil, garlic and dried hot pepper. Pollution and overfishing have made genuine *angulas* scarce and prohibitively expensive.

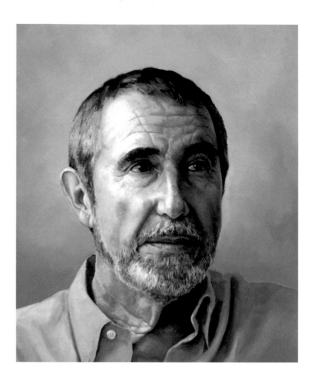

JUAN ZABALA
(WORK IN PROGRESS)
Joel Ely
Oil on canvas
305 x 254mm
(12 x 10")

JUAN ZABALA

Juan is the president of *Txoko Mallona* and consequently the member I spent most time with. He and his wife Maria Jesus generously shared many of their recipes and cooking techniques, from the correct way to cut potatoes for stews to the right kind of alcohol to flame-cook mushrooms and how to tell if tuna and squid were fresh in the market. There was much debate between the two on the exact way to approach each dish.

I asked Juan about how the *txoko* has changed over the years and how it might change in the future. Would it ever allow female members? Juan freely admitted the *txoko* was a conservative society, stressing that it was about community and cooking Basque dishes with the best ingredients. Women were regularly invited as guests but the rules stated only men could be members.

ACKNOWLEDGEMENTS

My thanks and congratulations go to the three short-listed artists and those selected for the exhibition, and I offer my grateful acknowledgement to all the artists who entered the BP Portrait Award 2006.

I would like to thank a very hard-working and determined set of judges: Sarah Howgate, Lucy Jones, Waldemar Januszczak and Des Violaris. I am also very grateful to the judges of the BP Travel Award: Sarah Howgate, Des Violaris and Liz Rideal. I would particularly like to thank Margaret Forster for her catalogue essay, which traces some of the issues of portrait painting back across time. I am also grateful to Caroline Brooke Johnson for her editorial work, Anne Sørensen for designing the catalogue and to Sue Thompson for co-ordinating the 2006 BP Portrait Award exhibition. Pim Baxter, Joanna Banham, Fiona Crothall, Denise Ellitson, Neil Evans, Ian Gardner, Sylvia Lahav, Eddie Otchere, Jonathan Rowbotham, Jude Simmons, Rosie Wilson and colleagues in Design, Communications and Development, Education, Exhibitions and other departments have contributed very helpfully and I am grateful to them. My thanks also go to the white wall company for their valuable contribution during the selection and judging process.

SANDY NAIRNE
Director, National Portrait Gallery

PICTURE CREDITS

All works copyright © the Artist, except for p.11, p.14 © National Portrait Gallery, London; p.12 © The Estate of Dame Laura Knight/DACS 2006. The publisher would like to thank the copyright holders for granting permission to reproduce works illustrated in this book. Every effort has been made to contact the holders of copyright material, and any omissions will be corrected in future editions if the publisher is notified in writing.

INDEX

Figures in *italics* refer to illustrations.